D0983477

KIKI SMITH

Telling Tales

HELAINE POSNER *and* KIKI SMITH

INTERNATIONAL CENTER OF PHOTOGRAPHY, NEW YORK

Introduction

For an increasing number of contemporary artists, photography has become an important tool for the exploration of ideas essential to the larger body of their work. On the most basic level, photography offers artists a means to reconsider concepts that they already understand through another medium, such as sculpture or painting. By narrowing their focus, they see in ways that confronting the whole might not encourage. And photography is quick, perfect for sketching—providing an informal, spontaneous outlet for ideas that may be elaborated in other forms.

This book is at once a catalogue for the exhibition *Telling Tales* and a work unto itself. In it, Kiki Smith uses the photographs from her exhibition to create a wholly new vehicle for her storytelling, one that incorporates images of her sculpture, paintings and drawings, as well as themes from her video works. In this rare sustained engagement with photography, Smith has created a loosely structured picture story with a narrative that is suggested, rather than overt. The book has intentionally been made small, like a children's book, in order to evoke our memories of the stories that inspire much of Smith's work.

The accompanying exhibition began as a simple show and grew to a major installation and book because of the shared enthusiasm of the artist and curatorial team. I want particularly to thank Kiki Smith for the energy she has given to make this a complex, multi-layered project, including making a litmited edition photograph available to ICP to benefit this catalogue. My thanks also go to

Helaine Posner for curating the exhibition and contributing the essay to this catalogue, and to the ICP curatorial staff, particularly Brian Wallis, Director of Exhibitions and Chief Curator, Kristen Lubben, Curatorial Assistant, Cynthia Fredette, Assistant Curator, and Vanessa Rocco, Curatorial Assistant. Appreciation is also due to PaceWildenstein and Pace/MacGill Gallery, New York, for their cooperation, and to Ann and Mel Schaffer for lending an important work from their collection to the exhibition.

Finally, Kiki Smith's exhibition and catalogue would not have been possible without the generosity of Anne and Joel Ehrenkranz. In their support they were joined by the members of ICP's Exhibitions Committee, as well as Diane and Tom Tuft. We are deeply grateful for their commitment to the artist and the institution.

WILLIS E. HARTSHORN
Ehrenkranz Director
International Center of Photography

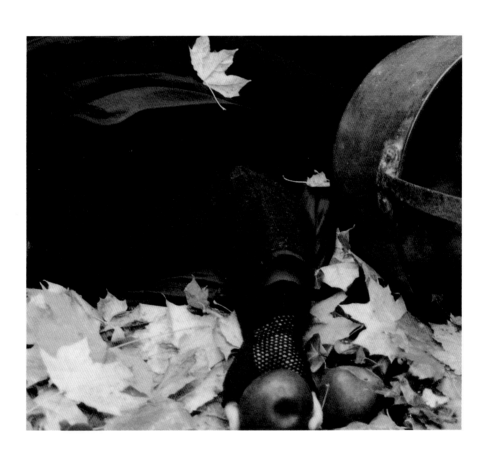

Once Upon a Time...

by HELAINE POSNER

Since she began making art in the early 1980s, Kiki Smith has also been telling stories. The overall tale Smith has told takes the form of her own creation myth, an engagement and reshaping of the religious, literary, and art-historical narratives that have defined the way we understand our origins and being, with the body as her focus. Although her primary reference has been the Christian creation story, she has also borrowed freely from diverse cultural traditions to express her personal vision. In Smith's creation tale, humanity begins in an abject state: Adam and Eve have fallen from grace. Once expelled from the Garden, they witness disease, death, and loss. The inevitable physical and psychological disintegration that follows is made manifest by Smith as isolated, fragmented, and damaged bodies or bodily parts. As her work has progressed, she has understood her mission to be nothing less than the healing of our fractured selves, and she has sought this renewal through remarkable depictions of such key Christian icons as the Virgin Mary and Mary Magdalene. Smith's goal in reinterpreting these tales is to restore humanity to a state of grace, envisioned as an ideal realm in which human beings, the animal world, and the landscape exist in harmony.[1]

Smith's extraordinary journey culminates in a return to the Garden of Eden. She arrives in an enchanted place that is the natural and miraculous setting of Biblical stories, myths, and fairy tales. A sense of wonder and innocence

Sleeping Witch, 2000
(with assistance of
Joey Kotting)
C-print

5

prevails, as if we are seeing the forest creatures and human inhabitants of this magical realm through the eyes of a child, poetically imagined yet charged with symbolic meaning. In Smith's garden, we discover the Old Testament figures of Eve and the serpent, as well as the fairy tale characters of Little Red Riding Hood and the wolf and Sleeping Beauty, and other mysterious companions. However, the sanctity of the garden is soon disturbed by curiosity and temptation. In each story, the heroine seeks more, and goes through a critical rite of passage or initiation to attain the experience and knowledge necessary for individual growth.[2] The ensuing loss of innocence is often fraught with risks, represented in these tales as encounters with witches or with cunning or dangerous beasts. It is the fear engendered by this quest and the painful vulnerability of childhood that Smith explores in her current body of work based on Biblical and fairy tale themes.

LITTLE RED RIDING HOOD

In *Telling Tales*, Smith has created three related multimedia environments, which employ sculpture, color photographs, paintings, drawings, stop-animation videotapes, and evocative soundtracks to immerse the viewer in her imaginary worlds. For the past two years, the artist has portrayed the subject of Little Red Riding Hood in various guises, some sweet and others quite startling. In this exhibition, Smith presents a series of color photographs of multiple images of Red Riding Hood painted on glass, depicting a wide-eyed young girl embarking on her journey

through life. Her portrait is drawn in a simple, linear style, with a guileless expression befitting Red Riding Hood's initial innocence. As we recall from traditional fairy tales, Red Riding Hood's mother had sent her into the

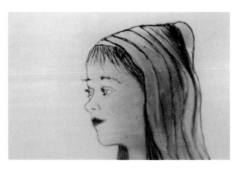

Gang of Girls and Pack of Wolves, 2000
C-print

woods with a basket of food to deliver to her sick grandmother. Along the way, she spoke to a sly wolf and naively revealed her destination. The hungry wolf dashed to grandmother's cottage and immediately proceeded to gobble up the old woman, as Riding Hood paused to gather strawberries and admire the flowers. Riding Hood later arrived at the cottage where she mistook the disguised wolf for her grandmother. At his bidding she got undressed and climbed into bed with him, whereupon he proceeded to devour her with his large teeth. Some versions of this tale have a happy ending: a kind huntsman kills the wolf, and delivers grandmother and Riding Hood from the belly of the beast.

The story of Little Red Riding Hood is a parable that advises children not to deviate from their duties or succumb to distracting temptations. It obviously warns girls to resist the seduction of the wolf or risk devastating consequences. But more importantly, the story works on a psychological level to address one of life's most difficult transitions. The tale of Little Red Riding Hood symbolically describes the perils of adolescence, particularly the girl's fear of her budding sexuality. Defined by her red cap, she is linked with violent and sexual feelings that initially she is too inexperienced to comprehend.[3] After Red Riding Hood manages to survive her terrifying ordeal and returns

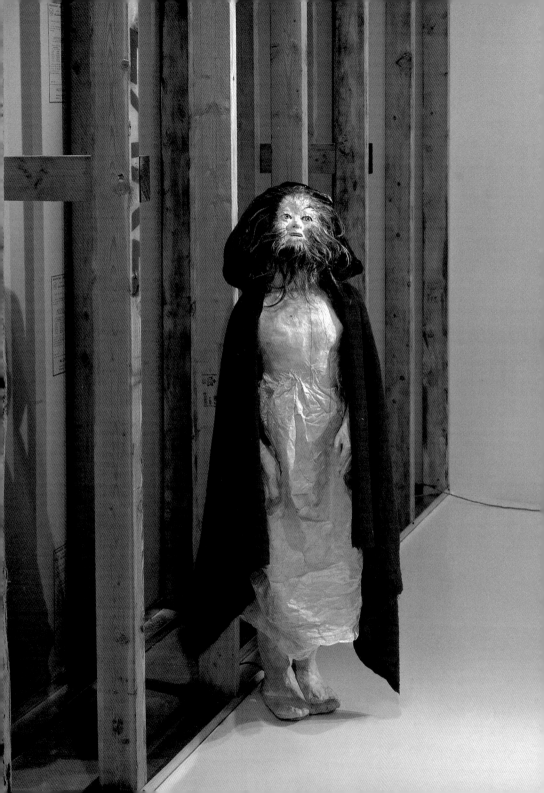

home safely, she gratefully thanks heaven for her miraculous rebirth, now a little wiser and better able to meet the challenges of life.

Smith's interpretations of Red Riding Hood include the innocent young girl seen in her color photographs and stop-animation videotapes, as well as a more complex and disquieting figure that explores childhood by placing its fears, traumas, and trials in the foreground. She is *Daughter* (1999), a white paper sculpture of a little girl standing about four feet high and wearing a deep-red wool cape and hood. Her face tilts up slightly to reveal the puzzled expression of a little girl who is lost and frightened. This is no wonder, since her head and face have unexpectedly sprouted wolflike fur.

The source for this particular image is a picture of a bearded girl that Smith came across in a French book on wolves and their interpretation through history. She found this child to be "so sweet, tender and wanton . . . an abandoned, forlorn little girl."[4] The artist was touched by this sad and strange being who is an outcast through no fault of her own. In her sculpture, Smith emphasizes the startling disparity between *Daughter*'s childlike demeanor and her mass of bushy facial hair. Perhaps, she suggests, the innocence of Red Riding Hood and the viciousness of the wolf are not as antithetical as we assumed. The artist shows us that even the gentlest creatures may possess a darker side and may quite suddenly manifest the aggressive, animalistic tendencies represented by the wolf. The notion of the merging of opposites is further reinforced by Smith's explanation of *Daughter*'s origins. The artist imagines a scenario in which Little Red Riding Hood and

opposite:
Daughter, 1999
(in collaboration with
Margaret Dewys)
Nepal paper, bubble
wrap, methyl cellulose,
hair, fabric, and glass

the wolf are outsiders who join together, marry, and give birth to *Daughter*. Their improbable offspring becomes the embodiment of male, female, and animal characteristics, the unique progeny of disparate beings.

In *Telling Tales*, Smith portrays the wolf in the form of a majestic, life-size bronze sculpture, based on her detailed drawings of a mounted wolf made at Harvard's Peabody Museum. The animal also appears in a series of close-up color photographs depicting bodily fragments, such as his eyes, snout, and paws. Smith represents the wolf as one of nature's creatures, not the anthropomorphic villain of the fairy tale. He is more a companion to Red Riding Hood than her enemy. The artist emphasizes this relationship between the two in a nearly fifty-foot-long series of paintings on glass, tellingly titled *Gang of Girls and Pack of Wolves* (1999) in which multiple images of each gather to form a marauding band. (Photographs of Red Riding Hood

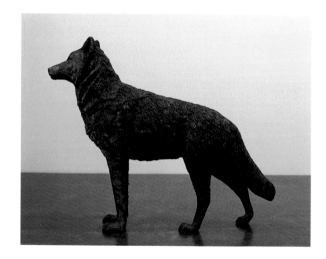

Genevieve and the May Wolf, 2000
Bronze

Bronze Wolf, 2000
(details)
C-prints

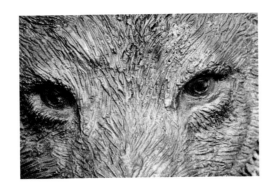

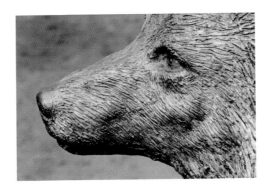

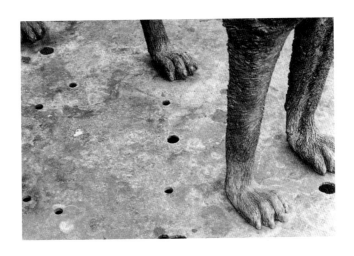

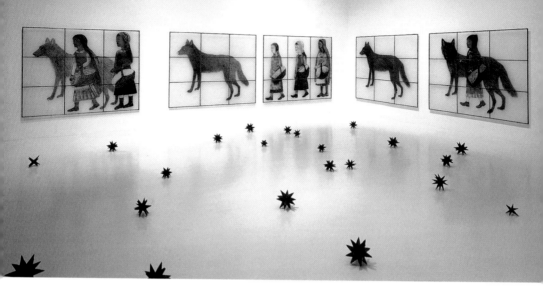

taken from this large work are included in *Telling Tales*,
although the painting is not.) Smith envisions this energetic
pair as colleagues in an effort to protect their fragile domain,
whether it is understood to be the enchanted garden or,
in contemporary terms, as our fragile environment. The
artist is deeply concerned about the threats posed to the
natural world by human intervention, and suggests that
Red Riding Hood and the wolf, in symbolic partnership,
may take on the mission of healing the damage, to restore
a green world.

EVE

*Gang of Girls and Pack
of Wolves*, 1999
Fired paint on glass
with brass and lead

The Biblical account of the Creation is the archetypal story
of humanity's passage from innocence to experience. In
this ancient tale, God creates Adam and Eve, the original

couple, and offers them a life of eternal bliss within the Garden of Eden, provided they do not eat the fruit of the Tree of Knowledge of Good and Evil. Eve yields to the temptations of the serpent and, with Adam, disobeys God's commandment and eats the forbidden fruit. God recognizes their transgression and proclaims their punishments, to be endured by them and by their genders for all time: for woman, pain in childbirth and subordination to man, and, for man, relegation to an afflicted ground where he must toil and sweat for his subsistence.

"To me," Smith has said, "the most essential thing is your spiritual life."[5] Over the course of her career, she has created full-scale figurative sculptures of such important religious icons as the Virgin Mary, Mary Magdalene, and Lilith, representing them as both physical and spiritual beings. Imbued with a deep sense of humanity, they embody suffering and hope. In comparison, Smith's sculpture of *Eve*, the first woman, is a far more modest creation. She is a diminutive figure, standing only twenty inches high, with her arms raised to reach for apples or, perhaps, the heavens. Smith greatly admires Northern Late Gothic and early Renaissance art, and she has modeled her image of *Eve* on the paintings of Lucas Cranach the Elder, the sixteenth-century artist known for his skill at depicting female beauty in a graceful, linear style. She has also been influenced by traditional Chinese Kuan Yin figures, small-scale sculptures depicting a beautiful young woman who is the personification of divine compassion in Buddhism. Smith's *Eve* appears poised on the brink of womanhood, still innocent and lovely, yet ultimately bearing the responsibility for humankind's fall from grace.

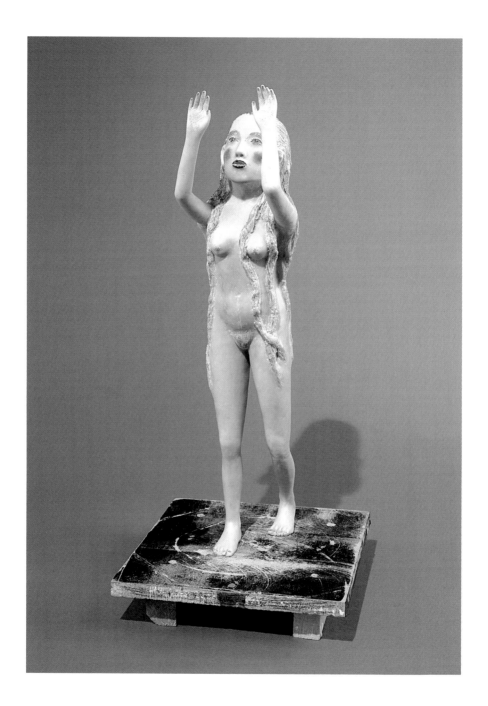

In traditional interpretations, Eve, and by extension all women, are considered weak, easily tempted and seduced, and the cause of pain, distress, and death due to Original Sin. Smith does not absolve Eve of blame but, like many contemporary feminists, sees her role as far more interesting and complex. By eating the apple at the snake's urging, Eve becomes the activator, the person who sets things in motion. After the Fall, we may be deprived of the eternal joy and serenity of the Garden, but we gain the very qualities that make us human. By committing the first act of transgression and partaking of the apple, Eve acquires knowledge of good and evil; in losing her innocence she has become capable of both moral judgement and spiritual growth. According to Smith, Eve marks the beginning of "ego consciousness" or the emergence of a more mature and integrated sense of self.[6] She has become, in essence, an adult.

Yet, for all her significant gains, Eve remains tainted by her association with the malevolent snake. As Little Red Riding Hood was altered by her alliance with the wolf, the figure of Eve has been strikingly transformed by her collaboration with the serpent. In a pair of large-scale paintings on glass, two nearly identical bizarre creatures, each comprised of the body of a lizard and the head of a young woman, clutch the Tree of Knowledge. Their erect postures and heavenward gazes emphasize their humanity. Smith calls this fantastic hybrid, complete with claws and a tail, *Serpent*. Through this uncanny cross between a female and a reptile, the artist dramatically reveals Eve's dubious ties to nature, sorcery, and the instinctual, as well as the paradoxical character of the first woman. Surprisingly, the

Eve, 2001
Resin, marble dust, and graphite

15

source for this seemingly Surrealist-inspired image is, in fact, a figure from a Northern Renaissance painting. In his diptych *The Fall of Man and The Lamentation* (1470–75), the Flemish painter Hugo van der Goes portrayed Adam and Eve in the Garden accompanied by the serpent in the form of a large lizard with a woman's head. Van der Goes's fifteenth-century figure has become Smith's contemporary *Serpent* and the disturbing spirituality often noted in his work has been incorporated into her own.

Kiki Smith takes a meandering approach to storytelling as she borrows from and blends the imperfectly remembered tales of childhood. In her estimation, the fairy tale figures of Sleeping Beauty and Snow White both inhabit the enchanted garden with Eve and share the consequences of eating the forbidden fruit. Smith has effectively conflated the stories of these two princesses, who have each unwittingly incurred the wrath of a wicked old woman, bringing on what appears to be their premature deaths. An evil fairy casts a spell on Sleeping Beauty, declaring that she will prick her finger on the spindle of a spinning wheel and die. Snow White's wicked stepmother flies into a murderous rage when informed by a talking mirror that Snow White, not she, is "the fairest of them all." Disguised as an old witch, the stepmother offers the girl a poisoned apple, a bite of which causes her to fall into a deep sleep. Both Sleeping Beauty and Snow White are awakened from their prolonged slumber by a prince's kiss and his promise of marriage, events that signal the sexualized nature of their awakening.

Smith has depicted Sleeping Beauty as a small, ghostly white figure lying upon a low platform and enveloped in

tiny berries and branches. The artist has given her a
delicately sculpted plaster head and a rudimentary body
shaped from a piece of white cloth resembling a bedcover.
Her smooth, snowy, expressionless face and open eyes give
the correct impression that Beauty is in a trance. Smith
draws our attention to the ethereal whiteness of her other-
worldly face in a group of close-up photographic portraits
of the sleeping princess. With this figure in repose, Smith
highlights the period of deathlike sleep endured by both
Sleeping Beauty and Snow White as an essential step in
their passage from adolescence to adulthood. Their symbolic
journey has been filled with peril, yet their royal reward
is basically assured, since most fairy tales end happily.
The fate of Eve is, of course, far more painful and uncertain,
yet all three share the fundamental experiences of tempta-
tion, danger, and sexuality induced by eating the apple.
According to the psychologist Bruno Bettelheim, who has
written so eloquently about these stories in his book *The
Uses of Enchantment,* "In many myths as well as fairy tales,
the apple stands for love and sex, in both its benevolent
and dangerous aspect. An apple given to Aphrodite, the
goddess of love, showing she was preferred to chaste

Sleeping Beauty, 2000
C-print

17

goddesses, led to the Trojan War. It was the Biblical apple with which man was seduced to forswear his innocence in order to gain knowledge and sexuality. While it was Eve who was tempted by male masculinity, as represented by the snake, not even the snake could do it all by itself— it needed the apple."[7]

Smith is intrigued by the highly charged and ambivalent symbolism of the apple which can variously serve as "the source of Eve's enlightenment," the repository of sex and fertility, as well as the portent of danger and death.[8] She explores its darker implications in a work called *Black Apples* which consists of several cast bronze examples of the fruit scattered across the floor. The artist has given these robust Macintoshes a strange matte black patina, making them both attractive and repulsive, and emphasizing their association with poison and evil. She is also interested in the purveyors of the forbidden fruit, who, in her view, represent the malevolent forces at work against young women. In *Serpent*, Smith showed how the insidious snake not only tempted Eve but also became intimately connected with her. Now, in a stunning series of large color photographs, Smith has portrayed the wicked witch or evil stepmother as a Victorian woman somberly clad in a long black dress, hooded wool coat, and mesh gloves (cover). We discover this pale, romantic figure lying in a deathly sleep among the autumn leaves with a large, overturned bucket of the lethal black apples by her side and one grasped in her lifeless hand. It seems that the evil witch has fallen victim to her own crime in a startling yet satisfying twist of fate.

It may surprise us to learn that the witch depicted in these photographs is actually the artist herself. Among

Smith's favorite works of art is Donatello's wood sculpture of the old, emaciated Mary Magdalene (1454–55), a highly expressive work that captures a strong spirit within a withered body. The artist has described her ongoing fantasy, rooted in childhood, of being a witch or an old hag, who, like Mary Magdalene is "post-sexual, post-menopausal, post a sexually active life." As she puts it, "I have always thought of myself as the crone."[9] The artist takes pleasure in the subversive and liberating effects of her assumed status; she is beyond the challenges that characterize Eve's or Sleeping Beauty's coming-of-age and she is free to make trouble.

THE PUPPET

The third character encountered on our journey lacks the specific literary or religious identity of Red Riding Hood or Eve. She is both a familiar figure and an oddly elusive one. Smith's minimally articulated puppet appears quite fragile and hastily bandaged together, comprised of a white Nepal paper torso, limbs, and a head that have been cut apart and reconnected with white cotton fabric. Crude yet lovingly hand-made, she has a gentle, impassive face and blue-gray glass eyes that give her an eerily human air. This puppet figure, which is also seen in a series of shadowy and mysterious color photographs, is woven through with strips of fabric that extend from her body like the strings of a marionette. She remains, however, a limp and lifeless being, either sprawled across the floor or suspended in space. This highly vulnerable creature embodies the tenderness and terror of childhood.

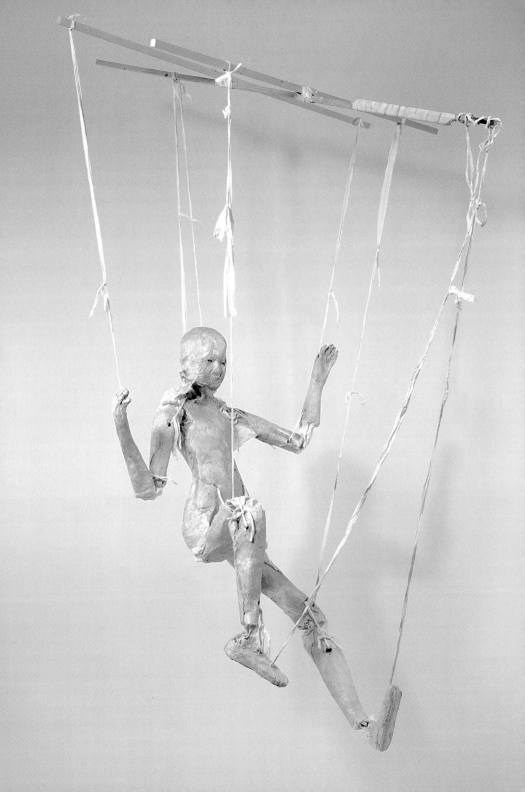

The puppet also touches on an important and recurrent theme in Kiki Smith's work, one that reveals her approach to making figurative art. The artist has stated that she feels compelled to take fragmented body parts—which may symbolize feelings of social and psychological alienation—and to reassemble them to make the body and spirit whole. In this way, she is able to heal the ruptured figure and, by implication, bring a dormant being back to life. She calls this her Frankenstein fantasy, likening herself to a mad scientist who builds composite bodies out of dismembered parts in a morbid, yet utopian attempt to mend and reanimate the dead. Like Frankenstein's monster the puppet is a poignant figure, brought to life to demonstrate the skills of others, yet bereft of power. She is the very embodiment of pathos, and, through her, "the wounds and fractures of human existence . . . become tangible."[10]

The puppet evokes compassion, in part, because she appears to be a child precariously poised between life and death. In fairy tales, we have seen how the seeming death of a young person intensifies the drama and serves as a rite of passage, leading figures like Red Riding Hood and Sleeping Beauty to greater maturity and growth. The melancholy puppet reflects an earlier period of passivity and evokes profound feelings of sadness and loss. Her only hope for animation lies in her relationship with the puppeteer or, in this case, the artist. Smith has made a videotape of herself, once again in the guise of a witch, performing several acts, including sweeping the floor and repeatedly lifting the puppet by its strings and then dropping it again. As the puppet continually falls to the ground, we begin to realize that all the artist's attempts

Puppet, 1999
Nepal paper, muslin, and glass

to manipulate this creature will be frustrated. Smith has given herself the Sisyphian task of bringing this inert being to life. Her efforts are, of course, futile, but we empathize with her as she pursues her deeply desired yet ultimately unattainable goal.

In *Telling Tales*, Kiki Smith takes an affectionate look at the formative fables of childhood. She is drawn to the sacred stories, folktales, and myths that creatively imagine a world that resembles our own, but is magically filled with fantastic beings and miraculous events—a world of dreams as well as nightmares. The artist translates these tales into a visual language of provocative beauty and psychological meaning, using familiar characters as guides through the stages of a woman's life. We mark the progress from youth to adolescence with Little Red Riding Hood and Sleeping Beauty, gain the experience to enter adulthood with Eve and approach old age through the bizarre figure of the wicked witch. Finally, the childlike puppet, in its fragmented state, serves as a moving reminder of the transitory nature of existence. Smith has introduced an astonishing range of human experience into the timeless simplicity of the enchanted garden, encouraging us to explore life's attendant pleasure and pain with the open, inquisitive spirit of a child.

NOTES

1. Helaine Posner, *Kiki Smith* (Boston: Bulfinch Press, 1998), p. 7–8.
2. Bruno Bettelheim, *The Uses of Enchantment: The Meaning and Importance of Fairy Tales* (New York: Vintage Books, 1989), p. 35.
3. Ibid., p. 173.
4. In conversation with the artist, October 23, 2000.
5. Michael Kimmelman, "Making Metaphors of Art and Bodies," *New York Times*, November 15, 1996, p. C1.
6. In conversation with the artist, October 23, 2000.
7. Bettelheim, *The Uses of Enchantment*, p. 212.
8. Kay Larsen, "The Big Apple," *Mirabella*, November, 1999, p. 20.
9. In conversation with the artist, October 23, 2000.
10. Carsten Ahrens, *Kiki Smith: All Creatures Great and Small* (Hannover, Germany: Kestner Gesellschaft, 1998), p. 9.

Dedicated to

KALI,

DENISE, *and* JACKIE

Bedlam

by KIKI SMITH

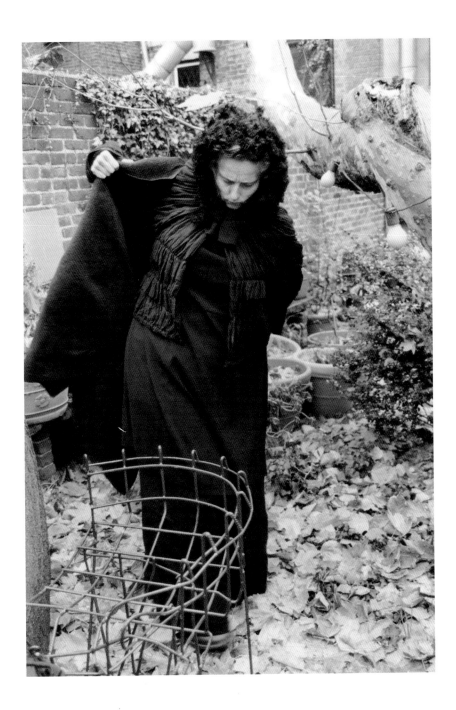

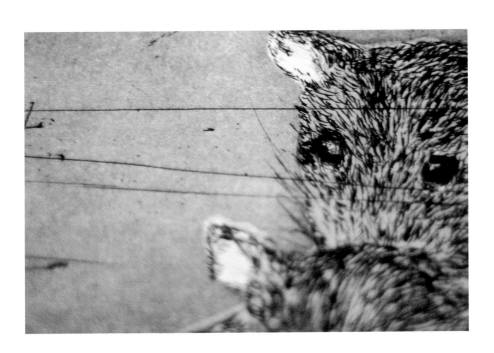

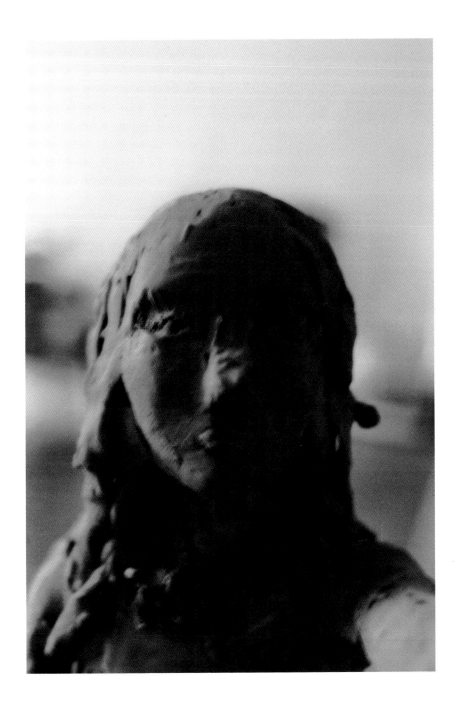

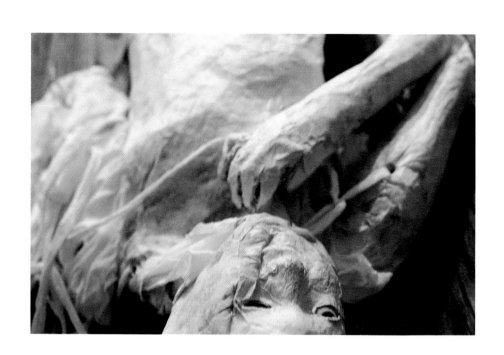

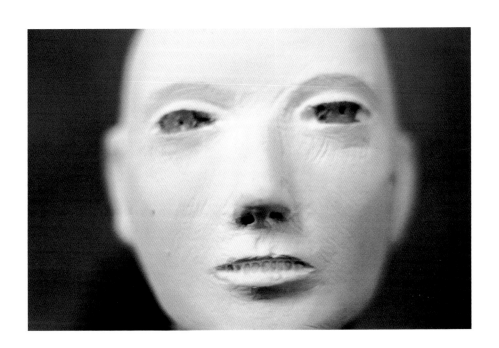

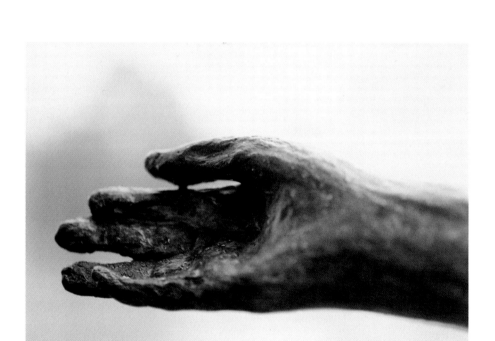

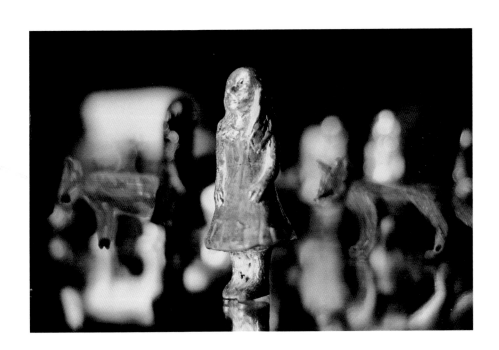

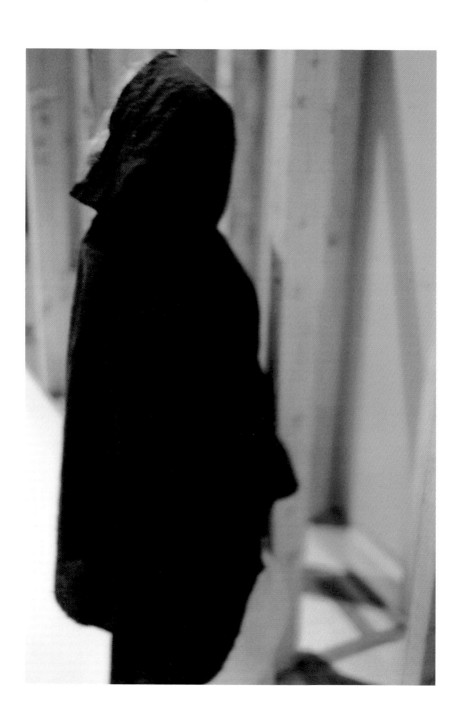

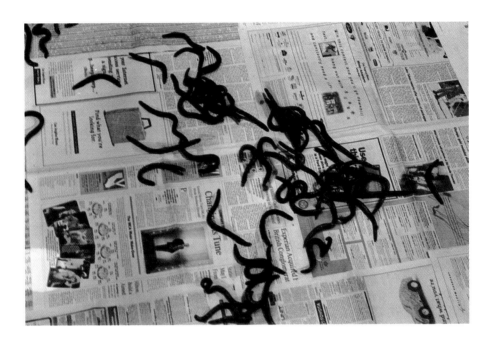

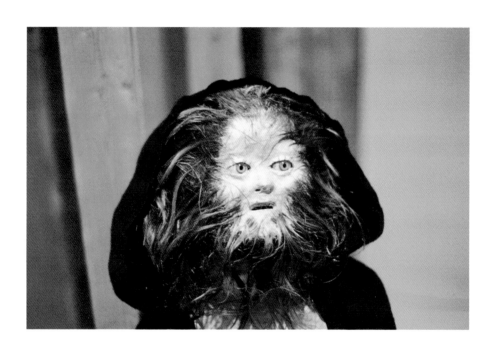

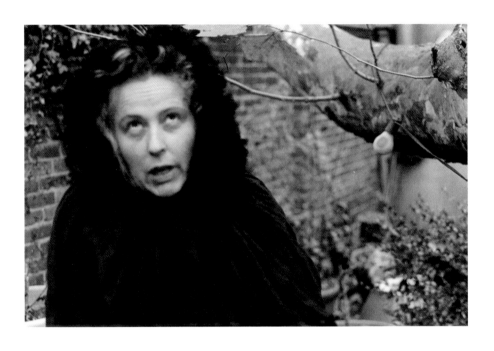

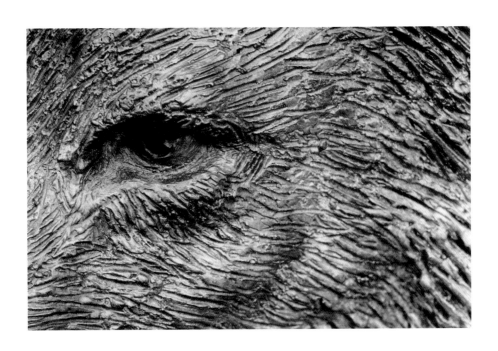

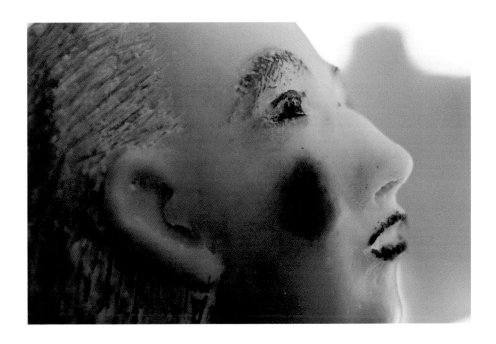

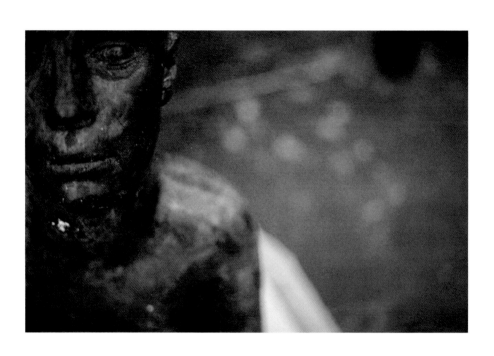

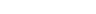
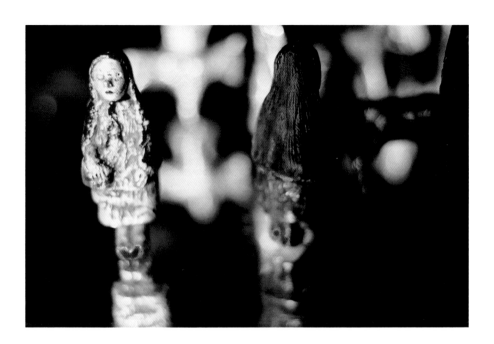

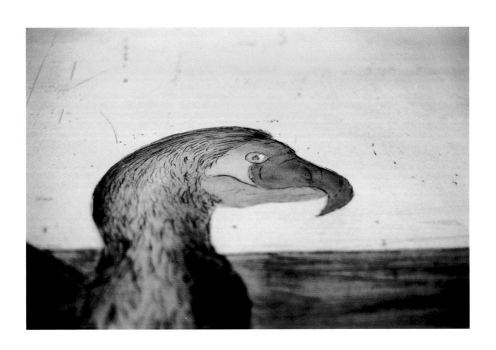

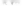
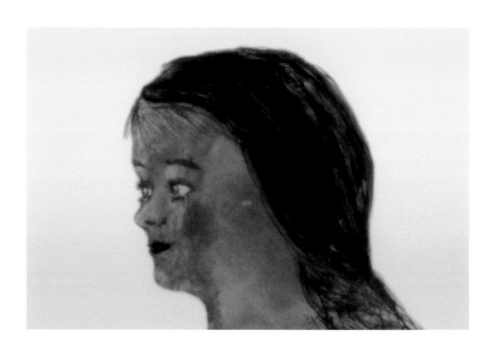

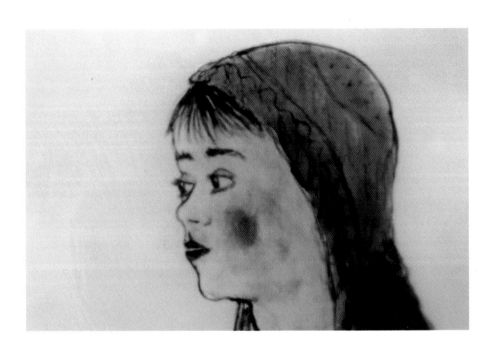

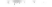
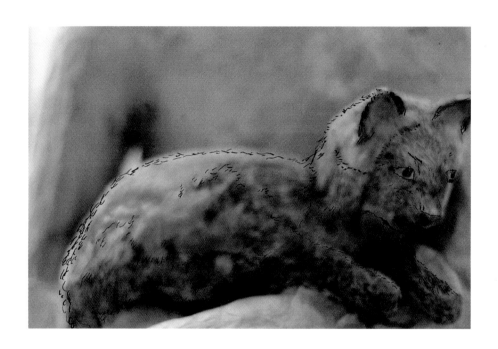

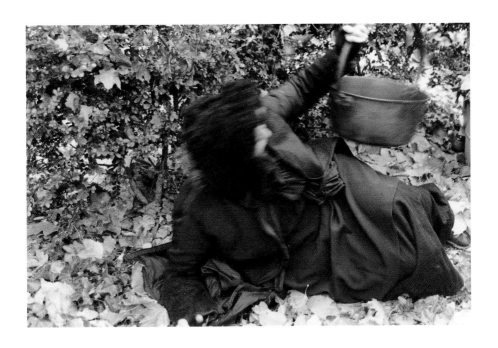

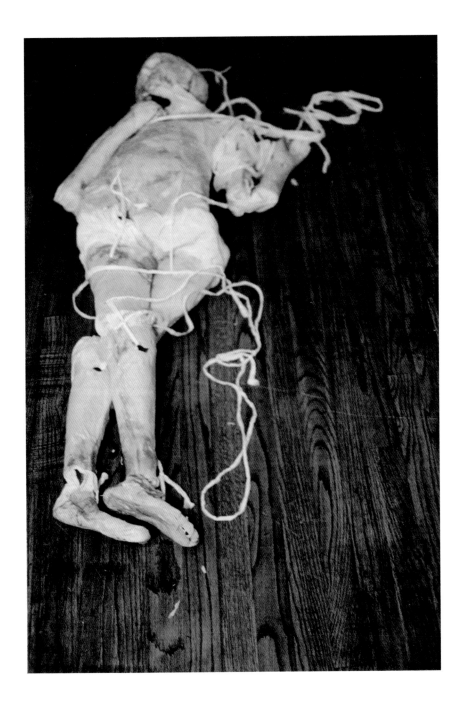

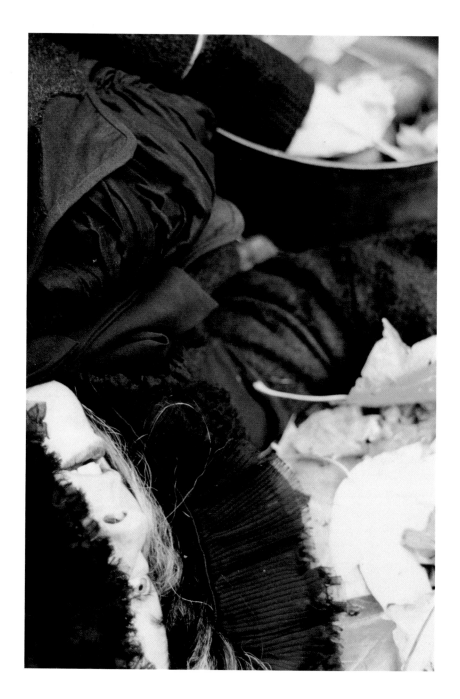

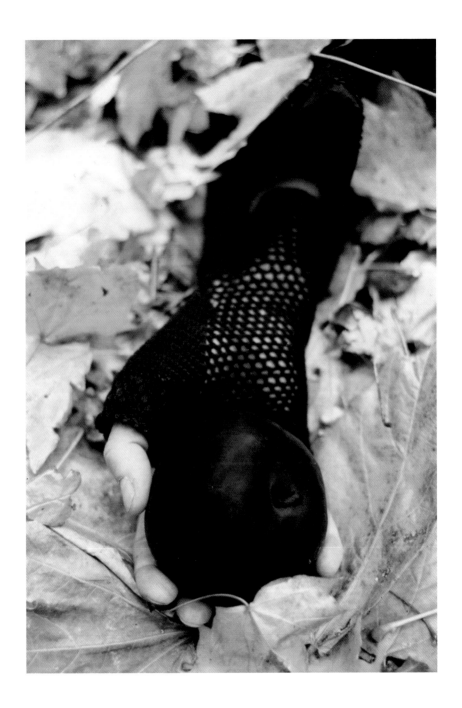

The End

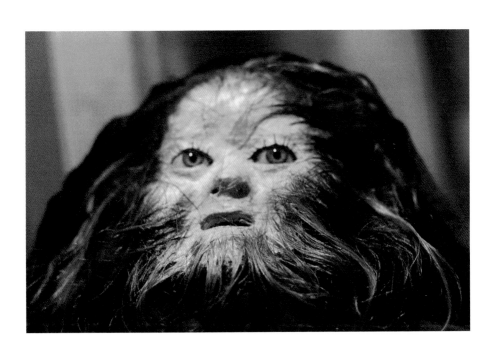

Little Red Riding Hood

Bronze Genevieve, 2000
7 C-prints
16 x 20 inches
Courtesy of the artist and
Pace/MacGill Gallery, New York

Bronze Wolf, 2000
5 C-prints
16 x 20 inches
Courtesy of the artist and
Pace/MacGill Gallery, New York

Companion, 2001
Lithograph
54 x 33 inches
Edition of 26
Published by Universal
Limited Art Editions, Inc.,
West Islip, New York
Courtesy of the artist

Companion, 2000
14 C-prints
4 x 6 inches
Courtesy of the artist and
Pace/MacGill Gallery, New York

Daughter, 1999
(in collaboration with
Margaret Dewys)
Nepal paper, bubble wrap,
methyl cellulose, hair, fabric,
and glass
48 x 15 x 10 inches
The Ann and Mel Schaffer
Family Collection

Daughter, 1999
13 C-prints
30 x 40 inches
Courtesy of the artist and
Pace/MacGill Gallery, New York

Daughter, 1999
4 C-prints
20 x 24 inches
Courtesy of the artist and
Pace/MacGill Gallery, New York

Gang, 2000
5 C-prints
4 x 6 inches
Courtesy of the artist and
Pace/MacGill Gallery, New York

*Gang of Girls and Pack of
Wolves*, 2000
12 hand-colored C-prints
16 x 20 inches
Courtesy of the artist and
Pace/MacGill Gallery, New York

Little Red Riding Hood, 1999
Pencil on paper
20 x 25 inches
Courtesy of the artist and
PaceWildenstein, New York

Night Wolf, 1999
Videotape
Courtesy of the artist and
PaceWildenstein, New York

Red Riding Hood, 1999
Videotape
Courtesy of the artist and
PaceWildenstein, New York

Wandering, 2000
Sterling silver
15 figures, 1 $^1/_2$ – 3 $^1/_2$ inches
high each
Courtesy of the artist and
PaceWildenstein, New York

Wandering, 2000
7 C-prints
11 x 14 inches
Courtesy of the artist and
Pace/MacGill Gallery, New York

Wandering, 2000
10 C-prints
4 x 6 inches
Courtesy of the artist and
Pace/MacGill Gallery, New York

Wolf, 2000
Bronze
Life-size
Courtesy of the artist and
PaceWildenstein, New York

Wolf, 1999
Pencil on paper
20 x 25 inches
Courtesy of the artist and
PaceWildenstein, New York

Wolf Drawings, 2000
2 hand-colored C-prints
16 x 20 inches
Courtesy of the artist and
Pace/MacGill Gallery, New York

Wolf Stream, 1999
Soundtrack
Courtesy of the artist and
PaceWildenstein, New York

Ève

Apples, 2000
3 C-prints
4 x 6 inches
Courtesy of the artist and
Pace/MacGill Gallery, New York

Black Apples, 1999
Bronze
Life-size
Courtesy of the artist and
PaceWildenstein, New York

Eve, 2001
Resin, marble dust, and
graphite
20 $^3/_8$ x 5 x 6 $^3/_4$ inches
Courtesy of the artist and
PaceWildenstein, New York

Eve, 2001
5 C-prints
20 x 30 inches
Courtesy of the artist and
Pace/MacGill Gallery, New York

Eve, 2001
16 C-prints
4 x 6 inches
Courtesy of the artist and
Pace/MacGill Gallery, New York

Eve, 1999
Pencil on paper
20 x 25 inches
Courtesy of the artist and
PaceWildenstein, New York

Eve, 2000
Videotape
Courtesy of the artist and
PaceWildenstein, New York

Eve, 2000
Soundtrack
Courtesy of the artist and
PaceWildenstein, New York

Necklaces, 2001
Gold-filled wire and silver
Dimensions variable
Courtesy of the artist and
PaceWildenstein, New York

Red Apples, 1999
Wax
Life-size
Courtesy of the artist and
PaceWildenstein, New York

Serpent, 1999
Fired paint on two glass
panels with brass and lead
89 $^1/_2$ x 23 $^3/_8$ inches each
Courtesy of the artist and
PaceWildenstein, New York

Sleeping Beauty, 2001
Plaster, fabric, plastic, and wire
4 x 22 x 28 inches
Courtesy of the artist and
PaceWildenstein, New York

Sleeping Beauty, 2000
2 C-prints
16 x 20 inches
Courtesy of the artist and
Pace/MacGill Gallery, New York

Sleeping Beauty, 2000
3 C-prints
20 x 30 inches
Courtesy of the artist and
Pace/MacGill Gallery, New York

Sleeping Witch, 2000
(with the assistance of
Joey Kotting)
12 C-prints
20 x 24 inches
Courtesy of the artist and
Pace/MacGill Gallery, New York

Sleeping Witch, 2000
(with the assistance of
Joey Kotting)
10 C-prints
4 x 6 inches
Courtesy of the artist and
Pace/MacGill Gallery, New York

Walled Garden, 2000
7 C-prints
4 x 6 inches
Courtesy of the artist and
Pace/MacGill Gallery, New York

The Puppet

Blood Noise, 1982
7 C-prints
4 x 6 inches
Courtesy of the artist and
Pace/MacGill Gallery, New York

Heads, 2000
3 C-prints
4 x 6 inches
Courtesy of the artist and
Pace/MacGill Gallery, New York

Mermaid, 2000
4 C-prints
4 x 6 inches
Courtesy of the artist and
Pace/MacGill Gallery, New York

Party Girl, 2000
Nepal paper, resin, and pencil
28 inches high
Courtesy of the artist and
PaceWildenstein, New York

Puppet, 1999
Nepal paper, muslin, and glass
54 inches high
Courtesy of the artist and
PaceWildenstein, New York

Puppet, 1999
Nepal paper, muslin, and glass
54 inches high
Courtesy of the artist and
PaceWildenstein, New York

Puppet, 2000
5 C-prints
20 x 24 inches
Courtesy of the artist and
Pace/MacGill Gallery, New York

Puppet, 2000
16 C-prints
4 x 6 inches
Courtesy of the artist and
Pace/MacGill Gallery, New York

Puppet, 2000
Videotape
Courtesy of the artist and
PaceWildenstein, New York

Teeth, 2000
10 C-prints
4 x 6 inches
Courtesy of the artist and
Pace/MacGill Gallery, New York

Worms, 1996–97
Polymer and oil paint
Dimensions variable
Courtesy of the artist and
PaceWildenstein, New York

Worms, 1996–97
3 C-prints
20 x 30 inches
Courtesy of the artist and
Pace/MacGill Gallery, New York

Worms, 1996–97
4 hand-colored C-prints
4 x 6 inches
Courtesy of the artist and
Pace/MacGill Gallery, New York

SELECTED EXHIBITIONS

KIKI SMITH
Born in Nuremerg, Germany,
1954
Lives and works in New York

Selected Solo Exhibitions

1990
Fawbush Gallery, New York

1990–91
Projects 24: Kiki Smith,
Museum of Modern Art,
New York
Kiki Smith, Centre d'Art
Contemporain, Geneva;
travels to Institute of
Contemporary Art,
Amsterdam

1991
*Kiki Smith: Matrix/Berkeley
142*, University Art
Museum, University of
California, Berkeley

1992
*Kiki Smith: Silent Work,
MAK* – Austrian Museum
of Applied Arts, Vienna
Kiki Smith, Moderna Museet,
Stockholm

1992–93
Kiki Smith: Unfolding the Body,
Rose Art Museum, Brandeis
University, Waltham,
Massachusetts; travels to
Phoenix Art Museum

Kiki Smith, Williams College
Museum of Art,
Williamstown,
Massachusetts; travels to
Wexner Center for the Arts,
Ohio State University,
Columbus

1993
Fawbush Gallery, New York

1994
Kiki Smith, Louisiana Museum
of Modern Art, Humlebaek,
Denmark; travels to
Kunstnernes Hus, Oslo
Kiki Smith, The Israel
Museum, Jerusalem

1994–95
Kiki Smith, The Power Plant,
Toronto

1994–96
*Prints and Multiples
1985–1993*, Barbara Krakow
Gallery, Boston; travels
to twelve venues in the
United States

1995
Kiki Smith, Whitechapel Art
Gallery, London; travels to
Galerie Rudolfinum, Prague
*Kiki Smith, Sculpture &
Drawings*, Anthony d'Offay
Gallery, London
New Sculpture,
PaceWildenstein, New York

1996
Landscape, Huntington
Gallery, Massachusetts
College of Art, Boston

1996–97
Kiki Smith, The Montreal
Museum of Fine Arts;
travels to Modern Art
Museum, Fort Worth, Texas
*Paradise Cage: Kiki Smith and
Coop Himmelb(l)au*, The
Museum of Contemporary
Art, Los Angeles

1997
Reconstructing the Moon,
PaceWildenstein, New York

1997–98
Kiki Smith: Convergence, Irish
Museum of Modern Art,
Dublin

1998
Directions Kiki Smith: Night,
Hirshhorn Museum and
Sculpture Garden,
Washington, D.C.
Kiki Smith, The Mattress
Factory, Pittsburgh
*Invention/Intervention: Kiki
Smith and the Museums*,
Carnegie Museum of Art,
Pittsburgh
*Kiki Smith: All Creatures
Great and Small*, Kestner
Gesellschaft, Hannover,
Germany

1999
Kiki Smith, Indianapolis
Museum of Art
Kiki Smith: Of Her Nature,
PaceWildenstein, New York

1999–2000
*My Nature: Works with Paper
by Kiki Smith*, The Saint
Louis Art Museum

2001
Kiki Smith: Telling Tales,
International Center of
Photography, New York

Selected Group Exhibitions

1990
The Body, The Renaissance
Society at the University
of Chicago
Witness Against Our Vanishing,
Artists Space, New York

1991
Body Language, Lannan
Foundation, Los Angeles
1991 Biennial Exhibition,
Whitney Museum of
American Art, New York

1991–92
*The Body Electric: Zizi
Raymond and Kiki Smith*,
The Corcoran Gallery of Art,
Washington, D.C.

1992
Post-Human, FAE Musee d'Art
Contemporain, Pully/
Lausanne, Switzerland;
travels to Castello di
Rivoli, Museo d'Arte
Contemporanea, Rivoli, Italy;

Deste Foundation for
Contemporary Art, Athens,
Greece; Deichtorhallen,
Hamburg, Germany

1992–93
Corporal Politics, MIT List
Visual Arts Center,
Cambridge, Massachusetts

1993
Aperto 1993, Venice Biennale
1993 Biennial Exhibition,
Whitney Museum of
American Art, New York
PROSPECT 93, Frankfurter
Kunstverein, Frankfurt

1994
In the Lineage of Eva Hesse,
The Aldrich Museum
of Contemporary Art,
Ridgefield, Connecticut

1995–96
Being Human, Museum of
Fine Arts, Boston
*Feminin-masculin: Le Sex de
l'art*, Musee d'Art Moderne
Centre Georges Pompidou,
Paris

1996
Conceal – Reveal, Site Santa Fe

1996–97
*Everything That's Interesting
is New: The Dakis Joannou
Collection*, Deste Foundation
for Contemporary Art,
Athens; travels to the
Museum of Modern Art,
Copenhagen; Guggenheim
Museum SoHo, New York

1997–98
*Proof Positive: Forty Years of
Contemporary American
Printmaking at ULAE,
1957–1997*, The Corcoran
Gallery of Art, Washington,
D.C.; travels to Armand
Hammer Museum of Art
and Cultural Center,
University of California,
Los Angeles; Sezon Museum
of Art, Tokyo; Kitakysyu
Municipal Museum of Art,
Kitakysyu City, Japan

1998
*Beyond Belief: Modern Art and
the Religious Imagination*,
National Gallery of Victoria,
Melbourne, Australia

1999
*The Virginia and Bagley
Wright Collection of Modern
Art*, Seattle Art Museum

1999–2000
*The American Century: Art
and Culture 1950–2000*,
Whitney Museum of
American Art, New York
*Regarding Beauty: A View of
the Late Twentieth Century*,
Hirshhorn Museum and
Sculpture Garden,
Washington, D.C.; travels
to Haus der Kunst, Munich

2000
Unnatural Science,
Massachusetts Museum of
Contemporary Art, North
Adams

SELECTED BIBLIOGRAPHY

Books and Exhibition Catalogues

Bradley, Jessica. *Kiki Smith*. Toronto: Power Plant, 1995.

Kiki Smith. The Hague: ICA/Amsterdam, Sdu Publishers, 1990. Texts by Paolo Colombo, Elizabeth Janus, Eduardo Lipshutz-Villa, Robin Winters, and Kiki Smith.

Kiki Smith. Humblebaek, Denmark: Louisiana Museum of Modern Art, 1994. Text by Anneli Fuchs.

Kiki Smith. London: Whitechapel Art Gallery, 1995. Text by JoAnna Isaak.

Kiki Smith. Montreal: Montreal Museum of Fine Arts, 1996. Texts by Christine Ross and Mayo Graham.

Kiki Smith: All Creatures Great and Small. Hannover, Germany: Kestner Gesellschaft, 1998. Text by Carsten Ahrens.

Kiki Smith: Silent Work. Vienna: MAK – Austrian Museum of Applied Arts, 1992. Texts by Peter Noever, Kiki Smith and R. A. Stein.

Kiki Smith: Unfolding the Body. Waltham, Mass.: Rose Art Museum, Brandeis University, 1992. Text by Susan Stoops.

My Nature: Works With Paper by Kiki Smith. Saint Louis: The Saint Art Museum, 1999. Text by Olivia Lahs-Gonzales.

Posner, Helaine. *Kiki Smith*. Boston: Bulfinch Press, 1998. Interview by David Frankel.

_____. *Kiki Smith: Telling Tales*. New York: International Center of Photography, 2001.

Projects 24: Kiki Smith. New York: Museum of Modern Art, 1990. Text by Jennifer Wells.

Rinder, Lawrence. *Kiki Smith: Matrix/Berkeley 42*. Berkeley, Calif.: University Art Museum, University of California at Berkeley, 1991.

Shearer, Linda and Claudia Gould. *Kiki Smith*. Williamstown, Mass.: Williams College Museum of Art; Columbus, Ohio: Wexner Center for the Arts, Ohio State University, 1992. Text by Marguerite Yourcenar.

Smith, Kiki. *Kiki Smith's Dowry Book*. London: Anthony d'Offay, 1997.

Periodicals

Boodro, Michael. "Blood, Spit, and Beauty." *ARTnews 93* (March 1994): 126-31.

Close, Chuck. "Interview with Kiki Smith." *Bomb*, fall 1994, 38-45.

Kimmelman, Michael. "Making Metaphors of Art and Bodies." *New York Times*, November 15, 1996, C1, 22.

Lyon, Christopher. "Kiki Smith: Body and Soul." *Artforum 28* (February 1990): 102-6.

McCormick, Carlo. "Kiki Smith." *Journal of Contemporary Art*, summer 1991, 81-95.

Tallman, Susan. "Kiki Smith, Anatomy Lessons." *Art in America 80* (April 1992): 146-53, 175.

Acknowledgements

I would like to thank Helaine Posner for conceiving of and bringing this exhibition to fruition through her diligence and patience, and for her thoughtful essay for this catalogue. I also wish to thank Director Buzz Hartshorn and the members of ICP's staff, especially Brian Wallis and Kristen Lubben, for their efforts. Thank you to Anne and Joel Ehrenkranz, ICP's Exhibitions Committee, and Diane and Tom Tuft for their contributions to this exhibition and catalogue.

Many thanks to my assistants Denise Fasanello, Jackie Janks, and Joey Kotting for their hard work. Also, a special thanks to Joey Kotting for his assistance with the "Sleeping Witch" photographs and *Puppet* videotape. Thanks to the students of Columbia University, particularly Eric Oldmixon, David Sun and Tomas Vu, and to the students of Alfred University's Institute for Electronic Art, for their help with the video animation. My appreciation goes to Exhibition Prints, especially Suzanne Saylor for her enormous work and kindness; to Bethany Johns for the beautiful design of this catalogue; and to Barry Frier of Baobab Frames for his advice. Thanks to PaceWildenstein and Pace/MacGill Gallery for their help and to Ann and Mel Schaffer for loaning *Daughter*.

I would also like to thank the artists, colleagues, and friends whose personal visions I admire. They include Genevieve Cadieux, Raimund Kummer, Barry LeVa, Cindy Sherman, Laurie Simmons, Seton Smith, David Wojnarowicz, Marnie Weber, Misaki Kawai, Eileen Cohen, Barbara Ess, and Sam Messer.

KIKI SMITH
February, 2001

Published in conjunction with the exhibition
KIKI SMITH: TELLING TALES
International Center of Photography
March 29 – June 10, 2001

ISBN 0-933642-28-8

Typeset in Celeste and Linoscript
Printed by Dr. Cantz'sche Druckerei,
 Germany
Designed by Bethany Johns

Distributed by D.A.P./
 Distributed Arts Publishers, Inc.
155 Avenue of the Americas, 2nd Floor
New York, NY 10013
tel: 212.627.1999
fax: 212.627.9484

Cover:
Sleeping Witch, 2000
(with the assistance of
Joey Kotting)
C-print

Photograph Credits:
Sleeping Witch – photograph by Kiki Smith,
 courtesy of the artist and Pace/MacGill
 Gallery, New York
Gang of Girls and Pack of Wolves (p. 7) –
 photograph by Kiki Smith, courtesy of the
 artist and Pace/MacGill Gallery, New York
Daughter – photograph by Ellen Page Wilson,
 courtesy of the artist and PaceWildenstein,
 New York
Bronze Wolf – photograph by Kiki Smith,
 courtesy of the artist and Pace/MacGill
 Gallery, New York
Gang of Girls and Pack of Wolves (p. 12) –
 photograph by Ellen Page Wilson, courtesy of
 the artist and PaceWildenstein, New York
Eve – photograph by Gordon R. Christmas,
 courtesy of the artist and PaceWildenstein,
 New York
Sleeping Beauty – photograph by Kiki Smith,
 courtesy Pace/MacGill Gallery, New York
Puppet – photograph by Gordon R. Christmas,
 courtesy of the artist and PaceWildenstein,
 New York

Photograph credits for *Bedlam*:
Photographs by Kiki Smith,
courtesy of the artist and
 Pace/MacGill Gallery, New York

Carrier, 2001 (detail)
Pool of Tears #2, 2000 (detail)
Pool of Tears #2, 2000 (detail)
Hand-colored etchings published by
 Universal Limited Art Editions, Inc.,
 West Islip, New York